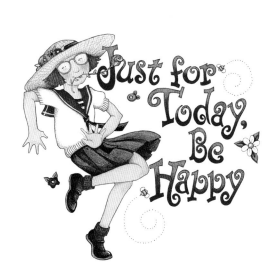

Just for Today, Be Happy

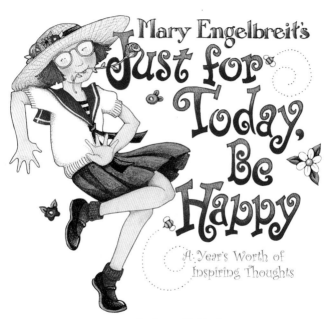

Mary Engelbreit's

Just for Today, Be Happy

A Year's Worth of Inspiring Thoughts

Andrews McMeel
Publishing

Kansas City

www.andrewsmcmeel.com
www.maryengelbreit.com

02 03 04 05 06 EPB 10 9 8 7 6 5 4 3 2 1

ISBN: 0-7407-2542-4

Illustrations by Mary Engelbreit
Design by Delsie Chambon

ATTENTION: SCHOOLS AND BUSINESSES

Andrews McMeel books are available at quantity discounts with bulk purchase for educational, business, or sales promotional use. For information, please write to: Special Sales Department, Andrews McMeel Publishing, 4520 Main Street, Kansas City, Missouri 64111.

Introduction

There is so much power in a positive attitude. I firmly believe that an upbeat approach or an affirmative thought—no matter how trivial it might seem—can turn a bad day into an okay day, or a good day into a spectacular one.

The most powerful positive thoughts are the simple ones: Be a friend. Say something nice. Delight someone. Believe in yourself. If only we could internalize just one of these ideas every day, imagine the cumulative effect over a year's time!

That's the idea behind this little book. On each of the book's 366 pages, you'll find one of my drawings accompanied by a simple thought to consider "just for today." A thought for every page, a page for every day. It's a simple

approach to bringing joy and greater meaning to your life—
but, after all, aren't the simple ways usually best?

I know that being happy isn't always as simple as having
a sunny attitude. The truth is that on some days, I find
it downright impossible to look on the bright side. We
all face setbacks, sad news, and disappointments,
but if we persevere through the tough times, the
good times have a way of sneaking back in before
we know it. My hope is that the words and pictures
in this book will be a daily reminder that there's lots
and lots to be happy about in life, and the best time to start
being happy is now!

Wishing you a wonderful today and a lifetime of happy
tomorrows.

Mary

Just for today...
stay in bed.

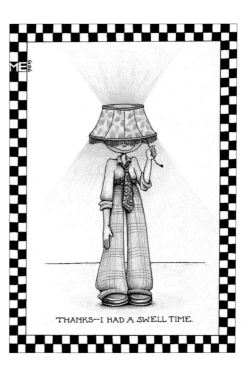

THANKS—I HAD A SWELL TIME.

january 1 · · · · · · · · · · · · · · · · · · ·

■ ■ ■

Just for today...

To make a man happy,
　　fill his hands with work,
his heart with affection,
　　his mind with purpose,
his memory with useful knowledge,
　　his future with hope,
　　　and his stomach with food.

—Frederick E. Crane

Just for today...
cuddle.

...IT IS NOT A SLIGHT THING
WHEN THEY, WHO ARE SO
FRESH FROM GOD,
LOVE US.

·DICKENS·

january 3 ·

Just for today...
take it easy.

Just for today...
be hopeful.

The grand essentials of
happiness are:
something
to do,
something
to love,
and something
to hope for.

—Allan K.
Chalmers

THE PLAYHOUSE

ALL YOU NEED IS A FRIEND

Just for today...
be a friend.

Just for today...
glide along.

january 7 .

Just for today...
hug someone.

Friends are treasures.
— Horace Bruns

■ ■ ■

*T*rue happiness . . . arises,
in the first place,
from the enjoyment of one's self,
and in the next,
from the friendship and conversation
of a few select companions.

—Joseph Addison

Just for today...
make a request.

■ ■ ■

Just for today...
persevere.

. .

Just for today...
do the
right thing.

Just for today...
nurture
someone.

While we try to teach our children
all about life, our children teach us
what life is all about.

—Angela Schwindth

Just for today...
chill out!

Just for today...
relax.

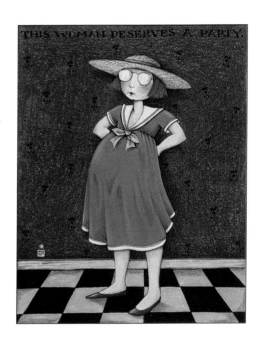

■ ■ ■

Just for today...

May you have
warmth in your igloo,
oil in your lamp,
and peace in your heart.

—Eskimo proverb

■ ■ ■

Just for today...
hold on
to what's
important.

Hold a true friend
with both
your hands.

—*Nigerian proverb*

january 17 ·

LOVING HANDS AT HOME

L.D.TESSIN

Just for today...
be creative.

■ ■ ■

Just for today...
broaden
your mind.

Just for today...
give your heart.

Just for today...
say something
nice.

MAKE THE MOST OF YOURSELF ······ FOR THAT IS ALL THERE IS OF YOU.

RALPH WALDO EMERSON

Just for today...
learn all
you can.

■ ■ ■

Just for today...

\mathscr{T}o do the useful thing,
to say the courageous thing,
to contemplate the beautiful thing:
that is enough for one man's life.

—T.S. Eliot

Just for today...
fantasize.

*I*magination is
the eye of the soul.
—*Joseph Joubert*

Just for today...
take care of
God's creatures.

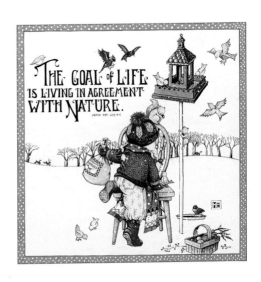

THE GOAL OF LIFE IS LIVING IN AGREEMENT WITH NATURE.
ZENO 335-263 BC

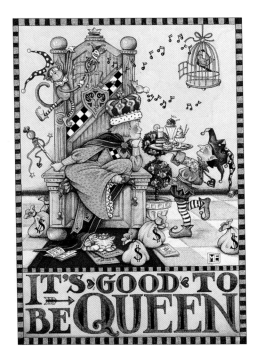

IT'S·GOOD·TO BE QUEEN

Just for today...
demand
the best.

Just for today...
get some
fresh air.

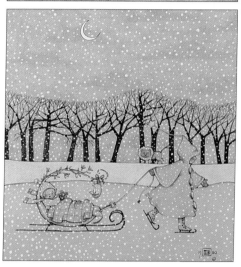

OVER THE RIVER

THROUGH THE WOODS

Just for today...
keep warm
inside.

Just for today...
cherish your
spouse.

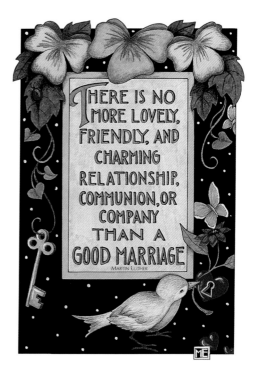

THERE IS NO
MORE LOVELY,
FRIENDLY, AND
CHARMING
RELATIONSHIP,
COMMUNION, OR
COMPANY
THAN A
GOOD MARRIAGE

MARTIN LUTHER

january 29

Just for today...

Happiness comes
from the capacity to feel deeply,
to enjoy simply,
to think freely,
to risk life,
to be needed.

—Storm Jameson

Just for today...
spoil yourself.

*𝒥f you are content, you have
enough to live comfortably.*

—*Titus Maccius Plautus*

Just for today...
be imaginative.

Just for today...
begin
something
grand.

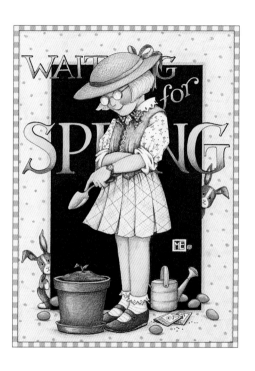

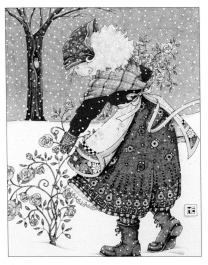

Just for today...
look beyond
and be hopeful.

Only with winter-patience
can we bring the deep desired
long awaited spring.
—*Anne Morrow Lindbergh*

Just for today...
follow your
heart.

\mathcal{N}o one
knows the limit
of the joy a heart can hold.

—Jan Miller Girando

Whatever you can do,
or dream you can,
Begin it.

GOETHE

Just for today...
take the
first step.

Do not worry;
eat three square meals a day;
say your prayers;
be courteous to your creditors;
keep your digestion good;
exercise; go slow and easy.
Maybe there are other things
your special case requires to
make you happy; but my friend,
these I reckon will give you a good lift.

—Abraham Lincoln

ST. BRIG
·ALL·SCHO
TALEN
SHOW
MRS. PERKINS
2ND GR. as
the
SUGAR PLUM
BEES

Just for today...
bask in glory.

The sweetest of all sounds
is praise.
—Xenophon

Just for today...
look
homeward.

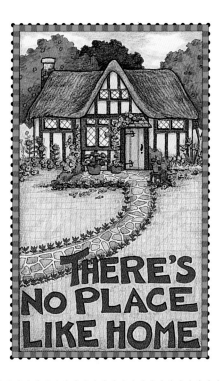

THERE'S NO PLACE LIKE HOME

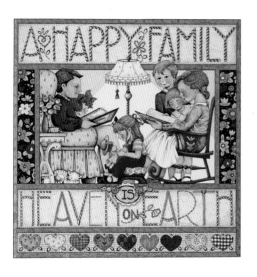

A HAPPY FAMILY

IS HEAVEN ON EARTH

Just for today...
feather
your nest.

■ ■ ■

Just for today...
be humble.

\mathcal{B}lessed be childhood,
which brings down something
of heaven into the midst
of our rough earthiness.

—*Henri Frédéric Amiel*

february 10

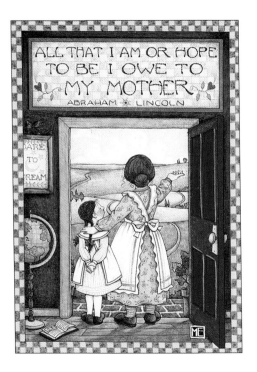

ALL THAT I AM OR HOPE
TO BE I OWE TO
MY MOTHER
ABRAHAM · LINCOLN

Just for today...
take direction.

■ ■ ■

Just for today...
look at the
funny side.

Laughter is the most
healthful exertion.

—*Christoph Wilhelm Hufeland*

february 12 · · · · · · · · · · · · · · · · ·

Have a variety of interests . . .
These interests relax the mind and
 lessen tension on the nervous system.
 People with many interests live,
not only longest, but happiest.

—George Matthew Allen

■ ■ ■

Just for today...
cherish the
moment.

For news of the heart
ask the face.

—*Guinean proverb*

EVERYONE NEEDS THEIR OWN SPOT.

ROBERT WHALEN

Just for today...
hold on tight.

The human heart,
at whatever age,
opens only to the heart
that opens in return.

—*Maria Edgeworth*

Just for today...
show affection.

february 16 .

IF YOU DON'T LIKE SOMETHING, CHANGE IT. IF YOU CAN'T CHANGE IT, CHANGE THE WAY YOU THINK ABOUT IT!

Just for today... take the initiative.

Just for today...
love
unconditionally.

THE
LAP of LUXURY

PRINCESS
OF
QUITE A LOT

Just for today...
live like
royalty.

Just for today...

\mathcal{T}he best philosophy
is to do one's duties,
to take the world as it comes,
submit respectfully to one's lot,
and bless the goodness that has
given us so much happiness with it,
whatever it is.

—Horace Walpole

february 20

WHEN YOU REACH THE END OF YOUR ROPE,
TIE A KNOT IN IT AND HANG ON.

–Thomas Jefferson

Just for today...
be determined.

Just for today...
be direct.

february 22

RUNNING AWAY.

Just for today...
start planning
a trip.

Just for today...
appreciate
family.

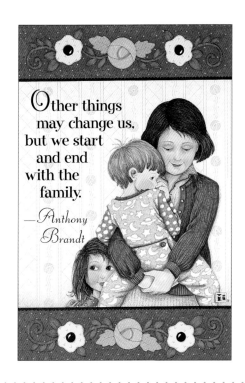

Other things
may change us,
but we start
and end
with the
family.

—Anthony
Brandt

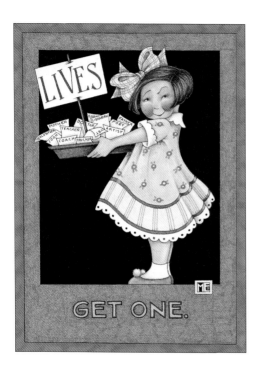

LIVES

GET ONE.

Just for today...
make a bold
statement.

Just for today...
enjoy the
little things.

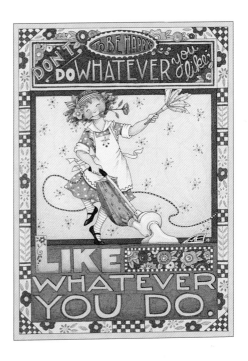

february 26 .

This is the day
which the Lord
hath made;
We will rejoice
and be glad in it.

—Psalms 118.24

Just for today...
be poised.

A good
head and a good heart
are always a formidable
combination.

—Nelson Mandela

LIFE IS JUST A
CHAIR OF BOWLIES

Just for today...
enjoy the
leap year.

Just for today...
be grateful.

Just for today...
harmonize.

Use what
talent you possess:
the woods would be
very silent
if no birds sang except those
that sang best.

—Henry Van Dyke

Just for today...
care for
someone.

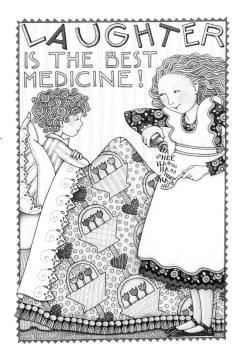

LAUGHTER
IS THE BEST
MEDICINE!

HA
HO HEE
HA HO HO
HA HA
HEE HEE
HA HO

Queens never
make bargains.
—*Lewis
Carroll*

Just for today...
compromise.

■ ■ ■

One is happy as a result
of one's own efforts—
once one knows the necessary
ingredients of happiness—simple tastes,
a certain degree of courage,
self-denial to a point,
love of work, and, above all,
a clear conscience.

—George Sand

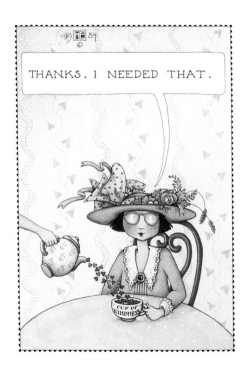

Just for today...
show your
appreciation.

■ ■ ■

Just for today...
admire
yourself.

*B*eauty is eternity
 gazing at itself in a mirror.
 —Kahlil Gibran

THE GOLDEN OPPORTUNITY
YOU ARE SEEKING IS IN
YOURSELF.

Just for today...
trust yourself.

Just for today...
take a
joy ride.

WHERE CHILDREN
ARE, THERE IS THE
GOLDEN AGE.
—NOVALIS

BOBBY
M
&
ALISON

TO KNOW IS NOTHING
AT ALL; TO IMAGINE IS
EVERYTHING.

ANATOLE
FRANCE
THIBAULT

Just for today...
dream.

■ ■ ■

Just for today...
share a secret.

𝒯he miracle of friendship
can be spoken without words . . .
hearing unspoken needs,
recognizing secret dreams,
understanding the silent things
that only true friends know.

In order to be utterly happy
 the only thing necessary
is to refrain from comparing
this moment with moments in the past,
 which I often did not fully enjoy
because I was comparing them
 with other moments of the future.

—André Gide

Just for today...
take a stroll.

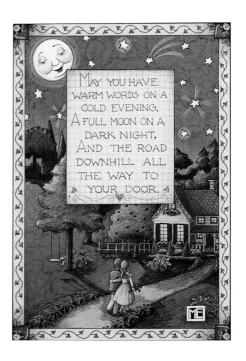

May you have warm words on a cold evening, a full moon on a dark night, and the road downhill all the way to your door.

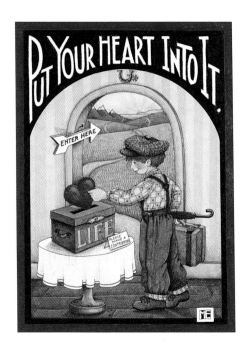

Just for today...
give your best.

Just for today...
find joy
in nature.

\mathcal{B}eauty is whatever
gives joy.

—Hugh Nibley

NOTHING
IS WORTH
MORE
THAN THIS DAY.

■ ■ ■

Just for today...
stay in
the moment.

Just for today...
wear green.

LUCK IS A VERY GOOD WORD IF YOU PUT A "P" BEFORE IT!

Just for today...
make a kind
gesture.

𝒯he fragrance always stays
in the hand that gives the rose.

—*Hada Bejar*

■ ■ ■

Just for today...

\mathscr{I}t is not easy
to find happiness in ourselves,
and it is not possible
to find it elsewhere.

—Agnes Repplier

Just for today...
get ready
for spring.

Just for today...
do unto others.

SOW GOOD SERVICES;
SWEET REMEMBRANCES
WILL GROW FROM THEM.
Mde. de Stael

Just for today...
listen to others.

Nature gave us one tongue
and two ears
so we could hear
twice as much as we speak.

—Epictetus

Just for today...
be in control.

THE QUEEN OF EVERYTHING

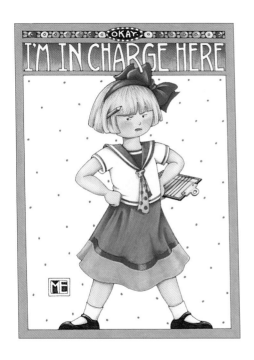

OKAY

I'M IN CHARGE HERE

Just for today...
take charge.

Just for today...
be playful.

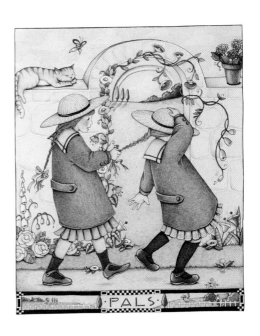

PALS

march 25 .

Happiness is not in our circumstances,
but in ourselves.
It is not something we see,
like a rainbow,
or feel, like the heat of a fire.
Happiness is something we are.

—John B. Sheerin

Just for today...
let nature be
your guide.

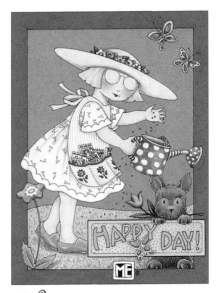

HAPPY DAY!

*Nature always tends to act
in the simplest way.*
—*Bernoulli*

march 27 .

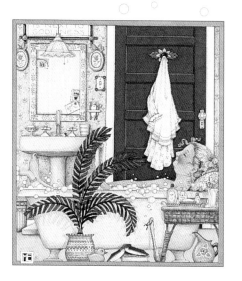

Just for today...
take a
bubble bath.

Just for today...
be courageous.

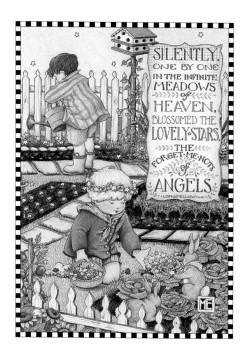

SILENTLY,
ONE BY ONE
IN THE INFINITE
MEADOWS
of
HEAVEN,
BLOSSOMED THE
LOVELY·STARS,
THE
FORGET·ME·NOTS
of
ANGELS
— LONGFELLOW —

Just for today...
be tender.

Just for today...
be a leader.

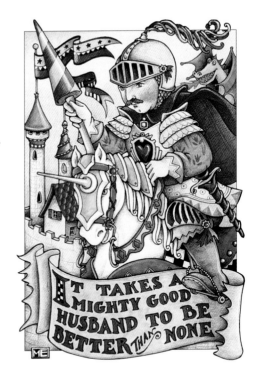

IT TAKES A MIGHTY GOOD HUSBAND TO BE BETTER THAN NONE

march 31

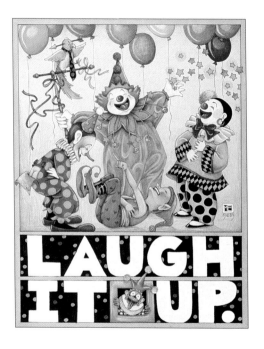

Just for today...
laugh.

Just for today...

The happiest people
seem to be those who
have no particular cause
for being happy
except that they are so.

— Dean William Ralph Inge

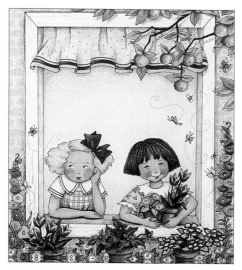

MOST FOLKS ARE ABOUT
AS HAPPY AS THEY MAKE
UP THEIR MINDS TO BE.
· ABRAHAM LINCOLN ·

Just for today...
be positive.

Just for today...
share your
knowledge.

If you have knowledge, let others light their candles by it.

ME

THANK A TEACHER

Just for today... sow some seeds.

Just for today...
bask in nature's
delights.

LITTLE ROBIN

april 6 .

Just for today...
set your
sights high.

\mathcal{D}reams are the touchstone
of our character.

—Henry David Thoreau

Just for today...
let little ones
help out.

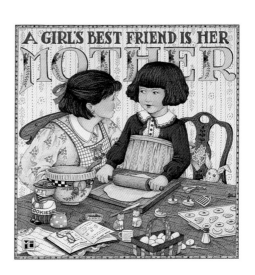

■ ■ ■

Just for today...

Happiness is a butterfly
which, when pursued,
is always beyond our grasp,
but, if you will sit down quietly,
may alight upon you.

—Nathaniel Hawthorne

Just for today...
bear all
cheerfully.

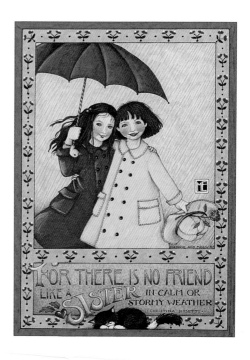

FOR THERE IS NO FRIEND
LIKE A SISTER IN CALM OR
STORMY WEATHER
CHRISTINA ROSETTI

april 10

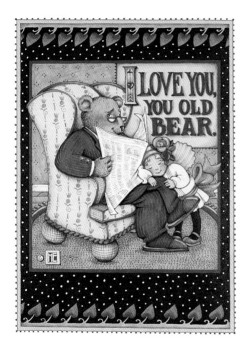

Just for today...
give someone
a "bear" hug.

Just for today...
envision the
future.

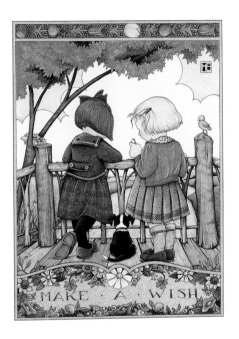

MAKE · A · WISH

april 12

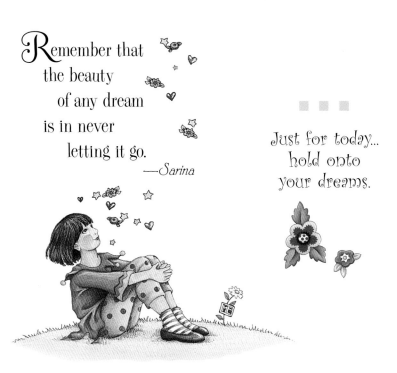

Remember that
the beauty
of any dream
is in never
letting it go.
—*Sarina*

Just for today...
hold onto
your dreams.

Just for today...
be optimistic.

In the dark of the moon, we have our dreams to light the path.

april 14

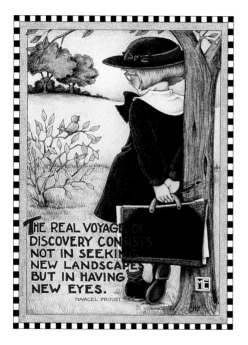

THE REAL VOYAGE OF
DISCOVERY CONSISTS
NOT IN SEEKING
NEW LANDSCAPES
BUT IN HAVING
NEW EYES.

MARCEL PROUST

Just for today...
begin your
discovery.

■ ■ ■

Just for today...

\mathcal{P}leasure is very seldom found
where it is sought.
Our brightest blazes
are commonly kindled
by unexpected sparks.

—Samuel Johnson

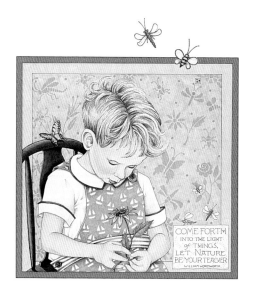

COME FORTH
INTO THE LIGHT
of THINGS,
LET NATURE
BE YOUR TEACHER
WILLIAM WORDSWORTH

Just for today...
be gentle.

Just for today...
rise above
it all.

𝒯here are many things in life
that will catch your eye,
but only a few will catch
your heart . . . pursue
these.

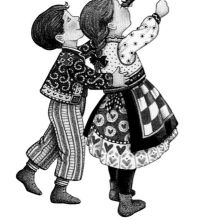

Just for today...
follow your
heart.

Kindness is more than deeds.
It is an attitude, an expression,
a look, a touch.
It is anything that lifts
another person.

—C. Neil Strait

Just for today...
give a little.

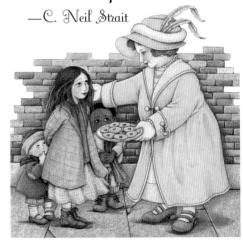

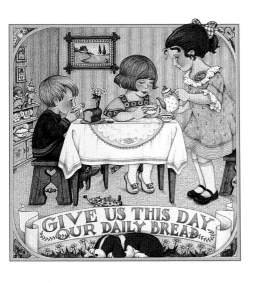

GIVE US THIS DAY
OUR DAILY BREAD

■ ■ ■

Just for today...
seek the
spiritual.

Just for today...
celebrate
spring.

THE QUEEN of the HOP

april 22

Just for today...

Now and then
it's good to pause
in our pursuit of happiness
and just be happy.

—*The Cockle Bur*

Just for today...
be generous.

Giving opens the way
for receiving.
—Florence Scovel Shinn

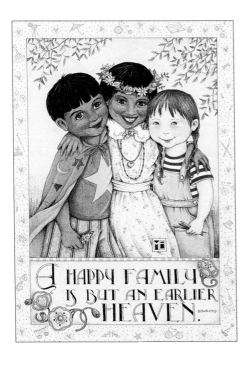

A HAPPY FAMILY IS BUT AN EARLIER HEAVEN. BOWRING

Just for today... treat your friends like family.

Just for today...
be the boss.

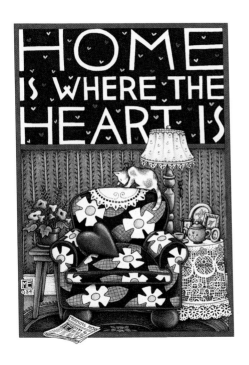

HOME
IS WHERE THE
HEART IS

Just for today...
sit awhile.

■ ■ ■

Just for today...
find shelter.

*I*f you want to be happy
 for a year, plant a garden;
if you want to be happy for life,
 plant a tree.

—*English proverb*

REMEMBER...
No Matter Where You Go...
There You Are.

Just for today...
live in the
moment.

Happiness sneaks in
through a door
you didn't know
you left open.

—John Barrymore

WOULD THAT THIS GARLAND FAIR
MIGHT WEAVE AROUND THY LIFE
A SPELL TO SHIELD FROM CARE
A GUARD FROM EVERY STRIFE

ANONYMOUS

Just for today...
pamper
a friend.

Of all the animals,
the boy is the
most unmanageable.

—*Plato*

Just for today...
get into
mischief.

■ ■ ■

Just for today...
believe in
miracles.

We have only to believe.
—*Pierre Teilhard de Chardin*

Just for today...
stay focused.

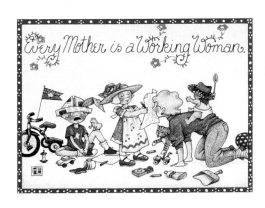

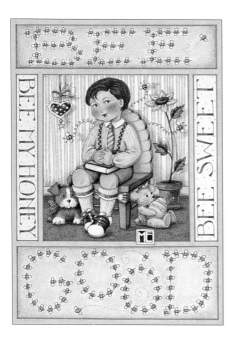

BEE MY HONEY

BEE SWEET

Just for today...
"bee" angelic.

Just for today...
be spontaneous.

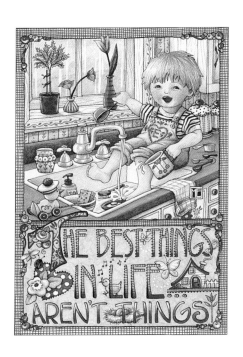

THE BEST THINGS IN LIFE AREN'T THINGS

may 6

■ ■ ■

Just for today...

Happiness is like a cat.
If you try to coax it or call it,
 it will avoid you.
It will never come.
But if you pay no attention to it
 and go about your business,
 you'll find it rubbing against your
 legs and jumping into your lap.

—William Bennett

Just for today...
enjoy the
morning.

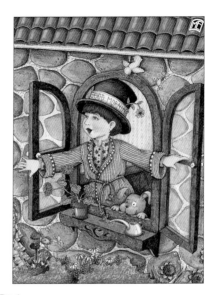

To be awake is to be alive.
—Henry David Thoreau

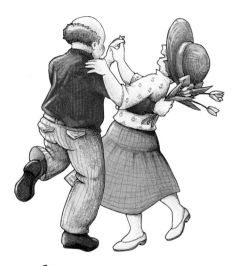

■ ■ ■

Just for today...
dance the
night away.

Old love
rusts not.
—*German proverb*

Just for today...
thank
a teacher.

\mathcal{W}ho dares to teach
must never cease
to learn.

—John Cotton Dana

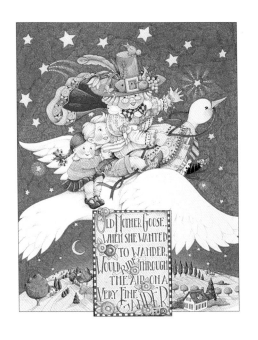

OLD MOTHER GOOSE, WHEN SHE WANTED TO WANDER, WOULD RIDE THROUGH THE AIR ON A VERY FINE GANDER

Just for today...
reach for
the stars.

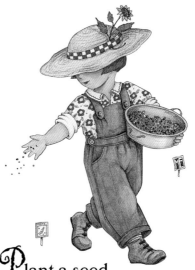

Just for today...
plant a garden.

\mathscr{P}lant a seed
of friendship; reap
a bouquet of happiness.

—Lois L. Kaufman

MY HOME IS IN MY MOTHER'S EYES.

Just for today...
remember
Mom.

■ ■ ■

Just for today...

\mathcal{H}appiness in this world,
 when it comes, comes incidentally.
Make it the object of pursuit,
 and it leads us on a wild-goose chase,
 and is never attained.
Follow some other object,
 and very possibly we may find
that we have caught happiness
 without dreaming of it.

—Nathaniel Hawthorne

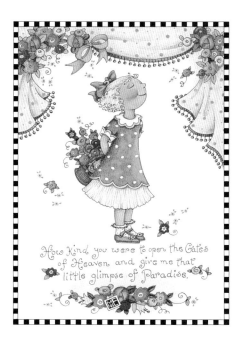

How kind you were to open the Gates of Heaven and give me that little glimpse of Paradise.

Just for today... compliment someone.

Remember, the greatest gift
is not found in a store
nor under a tree, but in
the hearts of true friends.

—*Cindy Lew*

Just for today...
be a true
friend.

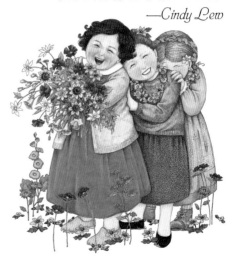

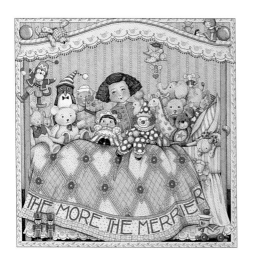

Just for today...
include
everyone.

Just for today...
serve others.

Just for today...
water the
flowers.

\mathcal{B}y cultivating the beautiful
we scatter the seeds of
heavenly flowers, as by doing
good we cultivate those that
belong to humanity.

—*Vernon Howard*

Just for today...
hug your
knight in
shining armor.

MY HERO

■ ■ ■

Happiness
 is not a goal,
 it is a by-product.

—Eleanor Roosevelt

Just for today...
follow
directions.

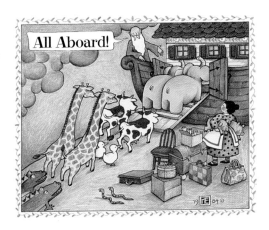

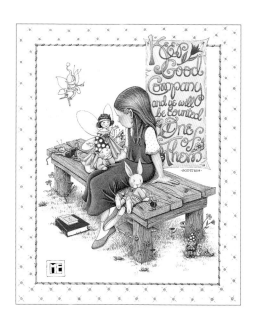

Keep
Good
Company
and ye will
be counted
One of
Them

—SCOTTISH

Just for today...
keep good
company.

Just for today...
act frankly.

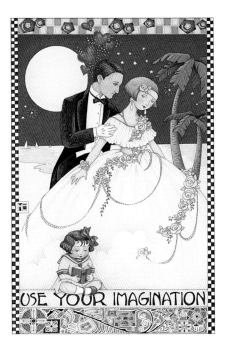

USE YOUR IMAGINATION

Just for today...
appreciate love.

Just for today...
make a
new start.

HEAL THE PAST;
LIVE THE PRESENT;
DREAM THE FUTURE.

may 26

OH, NO

Just for today...
accept your
mistakes.

■ ■ ■

Just for today...

Happiness is
when what you think,
what you say,
and what you do
are in harmony.

—Mahatma Gandhi

Just for today...
remember
those special
moments.

Such a one do I remember,
whom to look at was to love.
—Alfred, Lord Tennyson

Just for today...
mind your
manners.

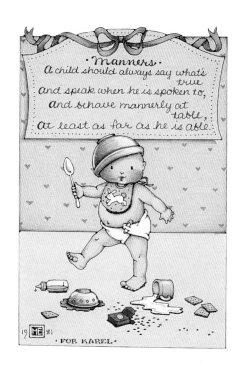

· Manners ·
A child should always say what's
true
and speak when he is spoken to,
and behave mannerly at
table,
At least as far as he is able.

19 ME 81
· FOR KAREL ·

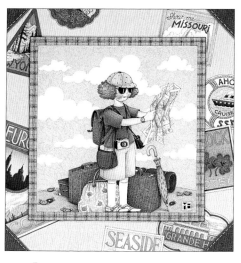

Just for today...
make your
own way.

𝒜dventure is worthwhile.

—𝒜melia Earhart

Just for today...
sit in the
moonlight.

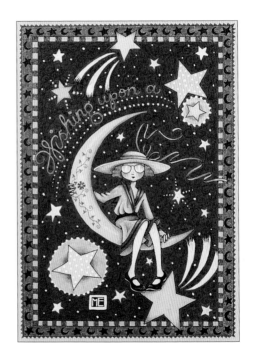

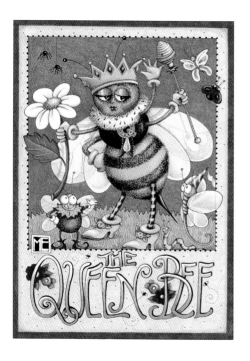

Just for today...
"bee" a honey.

■ ■ ■

Just for today...
be a team
player.

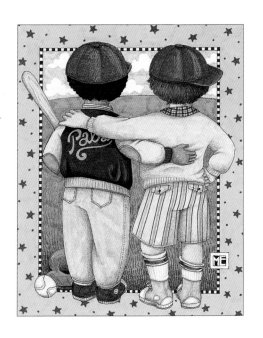

Just for today...

f you observe a really happy man,
you will find . . . that he is happy
in the course of living life
twenty-four crowded hours of each day.

—W. Beran Wolfe

Just for today...
think quietly.

We are
what we think.
All that we are
arises with
our thoughts.
With our
thoughts,
we make
the world.

—Buddha

BE KIND TO THY SISTER

NOT MANY MAY KNOW
THE DEPTHS OF TRUE
SISTERLY LOVE.

margaret courtney

Just for today...
hold someone's
hand.

Just for today...
be proud
of yourself.

Just for today...
hold nothing
back.

Just for today...
take a chance.

One that would have the fruit
must climb the tree.

—*Thomas Fuller*

\mathcal{A} mother understands
what a child does not say.

—Jewish
proverb

Just for today...
share feelings.

■ ■ ■

Just for today...

There is only one way to happiness,
and that is to cease worrying
about things which are beyond
the power of our will.

—Epictetus

Just for today...
spread
sunshine.

How doth the little busy bee
 improve each shining hour,
and gather honey all the day
 from every opening flower!
— Isaac Watts

Just for today...
hold onto
a friend.

AH! HOW GOOD IT FEELS
THE HAND of an OLD FRIEND
- LONGFELLOW

Just for today...
honor
Old Glory.

The union of hearts—
 the union of hands—
And the flag of our union
 forever.
 —*George Pope Morris*

Just for today...
stick together.

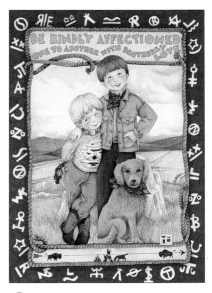

𝒜 brother is a friend
provided by nature.

—Legouve Pere

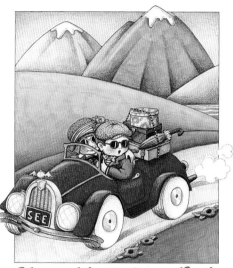

Always take the Scenic Route

Just for today...
enjoy the
scenery.

Just for today...
remember Dad.

NOTHING IS SO STRONG AS
GENTLENESS;
NOTHING SO GENTLE AS
REAL STRENGTH.

FRANCIS DE SALES

■ ■ ■

Just for today...

The secret of happiness
is not in doing what one likes,
but in liking
what one has to do.

—Sir James M. Barrie

Just for today...
enjoy the
summer
evening.

Just for today...
get some sun.

*L*ittle drops of water
 Little grains of sand,
Make the mighty ocean
 And the pleasant land.

—*Julia A. Fletcher Carney*

■ ■ ■

Just for today...
believe in
yourself.

What lies
ahead of you
and what lies
behind you
are nothing
compared to what
lies within you.

Just for today...
see beauty all
around you.

Just for today...
be content.

Marriages are
made in heaven and
consummated on earth.

—John Lyly

WE HAVE BEEN FRIENDS TOGETHER IN SUNSHINE AND IN SHADE.

Just for today...
be steadfast.

Just for today...

\mathcal{L}ife is not always
what one wants it to be,
 but to make the best of it as it is,
is the only way of being happy.

—Jennie Jerome Churchill

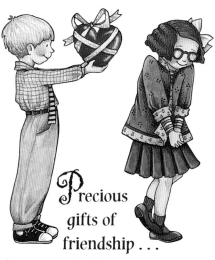

*P*recious
gifts of
friendship . . .
knowing the heart of another,
sharing one's heart
with another.

Just for today...
delight
someone.

Just for today...
be crafty.

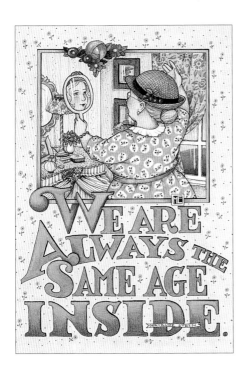

WE ARE ALWAYS THE SAME AGE INSIDE.

— GERTRUDE STEIN

Just for today...
be young
at heart.

Just for today...
take a walk
with a friend.

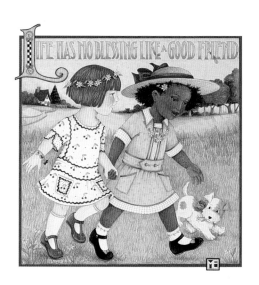

LIFE HAS NO BLESSING LIKE A GOOD FRIEND

TO IMAGINE IS EVERYTHING!

ME

Just for today...
think big
thoughts.

Just for today...
bear with it.

A. THE MOTHER. B. ALIEN TEENAGERS

THIS TOO SHALL PASS

■ ■ ■

*T*rue happiness...
is not attained through
self-gratification,
but through fidelity
to a worthy purpose.

—Helen Keller

Enthusiasm
moves the world.
—Arthur James
Balfour

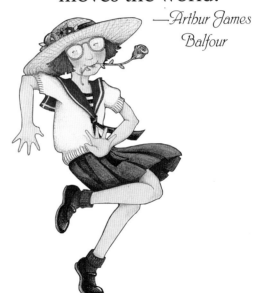

Just for today...
kick up
your heels.

LET FREEDOM RING

EVERYWHERE

Just for today...
be patriotic.

Just for today...
bask in
the sun.

A Day at
the Beach

july 5

MISS
SMARTY

Just for today...
show your
intelligence.

Just for today...
think pleasant
thoughts.

𝒯hinking: the talking
 of the soul with itself.
 —*Plato*

THE QUEEN OF EVERYTHING

Just for today...
notice the
little things.

■ ■ ■

Just for today...

\mathcal{T}he only ones among you
who will be really happy
are those who will have sought
and found how to serve.

—Albert Schweitzer

. .

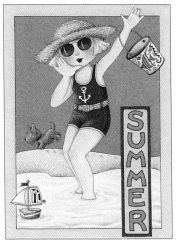

Just for today...
delight in
the season.

Ｔhere is no season
such delight can bring,
As summer, autumn, winter,
and the spring.

—William Browne

Just for today...
be earthy.

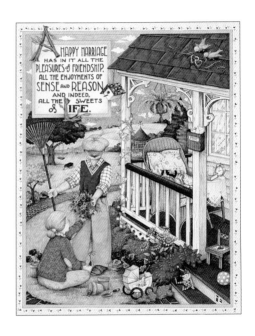

A HAPPY MARRIAGE HAS IN IT ALL THE PLEASURES OF FRIENDSHIP, ALL THE ENJOYMENTS OF SENSE AND REASON AND INDEED, ALL THE SWEETS OF LIFE.

Just for today...
dream of
new horizons.

\mathcal{M}y eyes are an ocean
in which my dreams
are reflected.

—Anna M. Uhlich

Just for today...
attend to
nature.

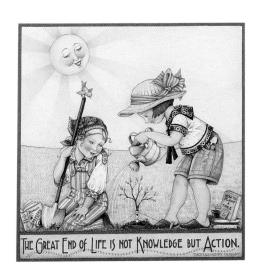

THE GREAT END OF LIFE IS NOT KNOWLEDGE BUT ACTION.
THOMAS HENRY HUXLEY

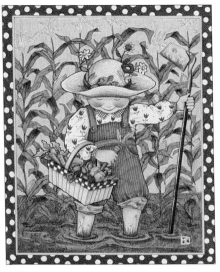

■ ■ ■

Just for today...
get dirty.

Gardening is an instrument
of grace.
—May Sarton

Just for today...
live your
values.

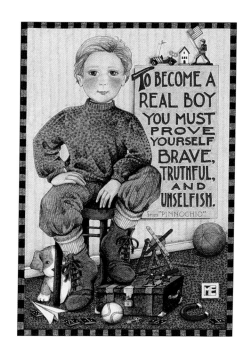

TO BECOME A
REAL BOY
YOU MUST
PROVE
YOURSELF
BRAVE,
TRUTHFUL,
AND
UNSELFISH.
from "PINNOCHIO"

ME

july 15 .

■ ■ ■

Just for today...

Happiness lies
in the joy of achievement
and the thrill of
creative effort.

—Franklin Delano Roosevelt

Just for today...
offer a gift.

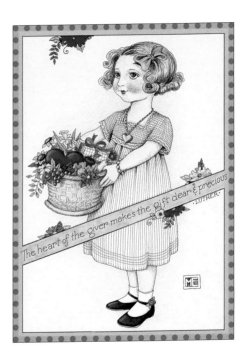

The heart of the giver makes the gift dear & precious
-LUTHER-

Just for today...
watch the
sunrise.

\mathcal{K}nock on the sky
and listen to
the sound.

—Zen saying

Just for today...
stand proud.

A MAN

AMONG MEN

The one absolutely unselfish friend that man can have in this selfish world is his dog.

Just for today... hug a dog.

\mathcal{T}he events of childhood
do not pass, but repeat
themselves like seasons
of the year.

—Eleanor
Farjeon

Just for today...
have balance.

SHOUT IT FROM THE ROOFTOPS

Just for today...
be heard.

■ ■ ■

The happiness of life
is made up of minute fractions—
the little, soon-forgotten charities
of a kiss or smile, a kind look,
a heart-felt compliment,
and the countless infinitesimals
of pleasurable and genial feeling.

—Samuel Taylor Coleridge

Just for today...
capture the
moment.

■ ■ ■

Just for today...
enjoy youth.

𝔄 boy's will is the wind's will,
And the thoughts of youth
are long, long thoughts.

—Henry Wadsworth Longfellow

■ ■ ■

Just for today...
play ball.

Just for today...
find a
quiet spot.

A GOOD WORD IS LIKE A GOOD TREE
WHOSE ROOT IS FIRMLY FIXED
AND WHOSE TOP IS IN THE SKY. THE KORAN

A really great talent finds its happiness in execution.

—Johann Wolfgang von Goethe

Just for today...
show off.

Just for today...
get with it.

july 29

Just for today...

For me it is sufficient to have
a corner by my hearth,
a book and a friend,
and a nap undisturbed
by creditors or grief.

—Fernandez de Andrada

Just for today...
air it out.

Hang your troubles out to dry...

■ ■ ■

Just for today...
share a book.

We shouldn't teach great
books, we should teach
a love of reading.
—Burrhus Frederic Skinner

Just for today...
lean on
someone's
shoulder.

LOVE COMFORTETH LIKE SUNSHINE AFTER RAIN.

WILLIAM SHAKESPEARE

\mathcal{Y}outh is happy
 because it has the ability
to see beauty. Anyone who
keeps the ability to see beauty
 never grows old.
 —Franz Kafka

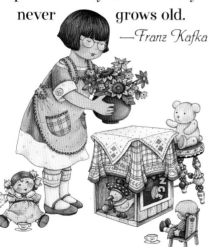

Just for today...
find simplicity.

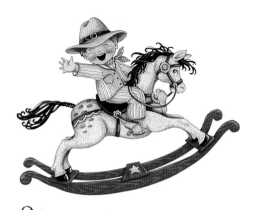

Just for today...
have a rockin'
good time.

When you're young,
 the silliest notions seem
 the greatest achievements.

—*Pearl Bailey*

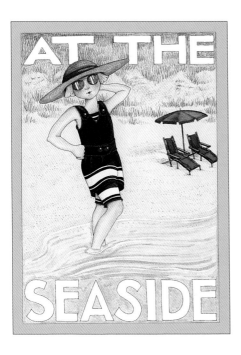

Just for today...
plan a getaway.

Just for today...

\mathcal{A} happy life is
made up of little things . . .
a gift sent, a letter written,
a call made,
a recommendation given,
transportation provided,
a cake made, a book lent,
a check sent.

—Carol Holmes

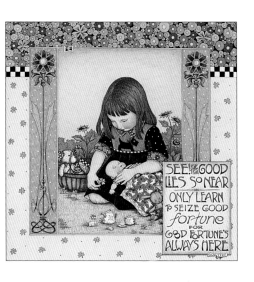

SEE! the GOOD
LIES SO NEAR
the
ONLY LEARN
to SEIZE GOOD
fortune
FOR
GOOD FORTUNE'S
ALWAYS HERE

Just for today...
find the good.

Just for today...
be aggressive.

SAVE THE WHALES

Just for today...
have a cause.

Just for today...
whistle a
happy tune.

\mathcal{M}usic washes away
 from the soul the dust
of everyday life.

—Red Auerbach

Just for today...
splash around.

\mathcal{S}ummer afternoon,
summer afternoon;
to me those have always been
the two most beautiful words
in the English language.

—*Henry James*

Just for today...
let your
imagination
run wild.

Yes, there is a Nirvanah;
it is in leading your sheep
to a green pasture,
and in putting your child to sleep,
and in writing the last line
of your poem.

—Kahlil Gibran

\mathcal{T}here is a destiny that
makes us brothers,
no one goes his way alone;
all that we send into the lives
of others, comes
back into our own.

—*Edwin Markham*

Just for today...
embrace life.

COUNT
YOUR
BLESSINGS

Just for today...
offer a
comfortable
shoulder.

Just for today...
indulge.

**Too much of a good thing
is wonderful.**

—Mae West

· · · · · · · · · · · · ·

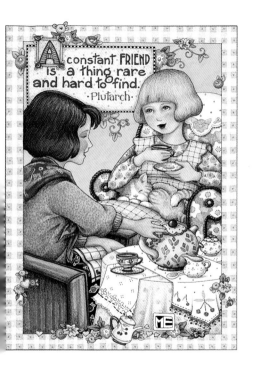

A constant FRIEND
is a thing rare
and hard to find.
· Plutarch ·

Just for today...
share tea
with a friend.

Just for today...
give of
yourself.

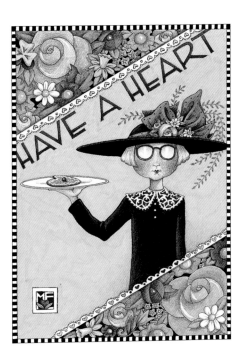

HAVE A HEART

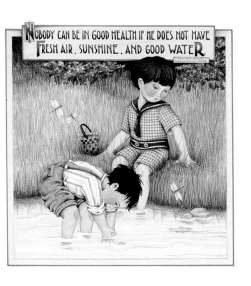

NOBODY CAN BE IN GOOD HEALTH IF HE DOES NOT HAVE FRESH AIR, SUNSHINE, AND GOOD WATER.
— FLYING HAWK
OGALA SIOUX CHIEF

■ ■ ■

Just for today...
get your
feet wet.

Just for today...

Happiness consists more in small conveniences or pleasures that occur every day, than in great pieces of good fortune that happen but seldom.

—Benjamin Franklin

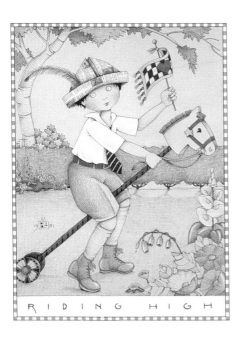

RIDING HIGH

Just for today...
make believe.

Just for today...
build castles.

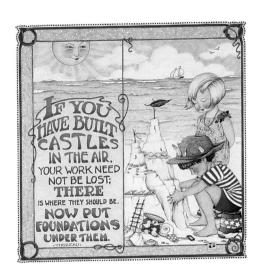

IF YOU HAVE BUILT CASTLES IN THE AIR, YOUR WORK NEED NOT BE LOST; **THERE** IS WHERE THEY SHOULD BE. **NOW PUT FOUNDATIONS UNDER THEM.**

-THOREAU-

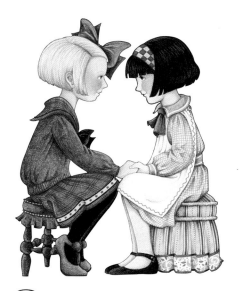

Just for today...
begin a new
friendship.

𝒫lant a seed of friendship;
reap a bouquet of happiness.
—Lois L. Kaufman

Just for today...
overlook
the mess.

\mathcal{A}bsence sharpens love,
presence strengthens it.

—Thomas Fuller

. . .

Just for today...
hang out
with friends.

Just for today...
find joy
in giving.

\mathcal{G}iving, whether it be of time,
labor, affection, advice,
gifts, or whatever, is one of
life's greatest pleasures.

— Rebecca Russell

Enjoy the little things,
for one day you may look back
and realize they were
the big things.

—Robert Brault

Just for today...
remember
your roots.

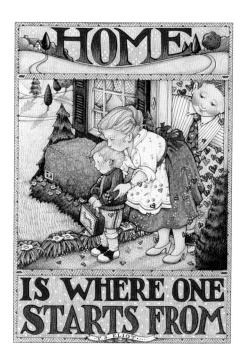

HOME
IS WHERE ONE
STARTS FROM

...T.S. ELIOT...

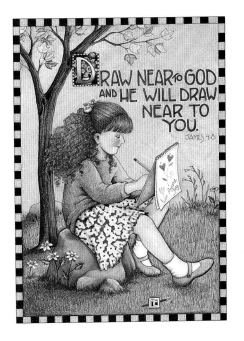

DRAW NEAR TO GOD AND HE WILL DRAW NEAR TO YOU.

JAMES 4:8

Just for today...
rely on faith.

Just for today...
return home
in your heart.

\mathcal{H}ome is an invention
on which no one
has yet improved.

—*Ann Douglas*

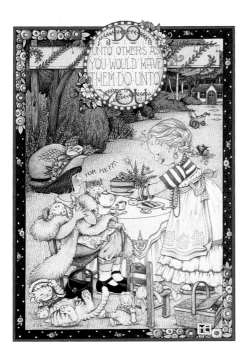

Just for today...
follow the
Golden Rule.

Magic is believing in yourself.

Just for today...
be a winner.

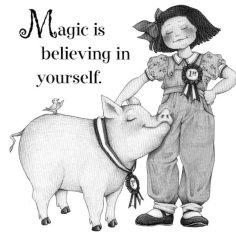

If you can do that,
you can make
anything happen.

—*Foka Gomez*

september 1 .

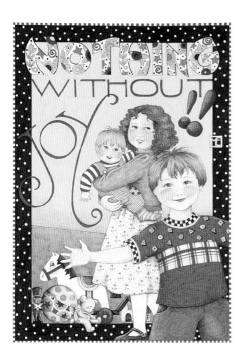

Just for today...
express joy.

Just for today...

\mathcal{T}he best things are nearest:
breath in your nostrils, light in your eyes,
flowers at your feet, duties at your hand,
the path of God just before you.
Then do not grasp at the stars,
but do life's plain, common work as it comes,
certain that daily duties and daily bread
are the sweetest things of life.

—Robert Louis Stevenson

september 3 .

WHO WELL LIVES, LONG LIVES;
FOR THIS AGE OF OURS
SHOULD NOT BE NUMBERED
BY YEARS, DAYS, AND HOURS.
· DU BARTES ·

Just for today...
rest.

september 4

\mathcal{W}ithin your heart,
keep one still,
secret spot
where dreams may go.

— *Louise
Driscoll*

Just for today...
be reflective.

MAKE A NEST OF PLEASANT THOUGHTS.

■ ■ ■

Just for today...
escape.

\mathcal{F}or thee
the wonder-working earth
puts forth sweet flowers.

—Titus Lucretius Carus

Just for today...
bloom where
you're planted.

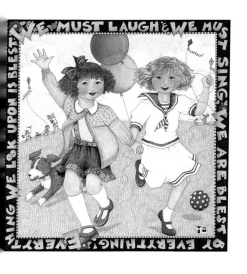

Just for today...
go to the park.

Just for today...
honor the
elderly.

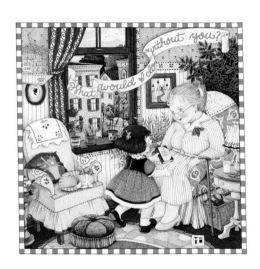

∎ ∎ ∎

Just for today...

If happiness depends
 on a good breakfast,
flowers in the yard,
 a drink or a nap,
then we are more likely to live
 with quite a bit of happiness.

—Andy Rooney

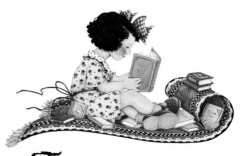

Just for today...
prepare
your mind.

\mathcal{T}oday a reader,
tomorrow
a leader.

—W. Fusselman

THAT'S WHAT FRIENDS ARE FOR.

THIS WAY

TO THE ENDS OF THE EARTH

10 KAJILLION TRILLION MI.

ME

Just for today...
go the
extra mile.

Just for today...
love with
all your heart.

\mathcal{L}ove is but the discovery
of ourselves in others, and
the delight in the recognition.

—Alexander Smith

The Girls

Just for today...
act child-like.

Just for today...
work on
a project.

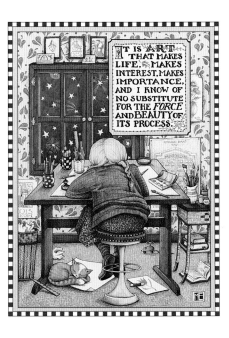

IT IS ART THAT MAKES LIFE, MAKES INTEREST, MAKES IMPORTANCE, AND I KNOW OF NO SUBSTITUTE FOR THE *FORCE* AND BEAUTY OF ITS PROCESS. HENRY JAMES

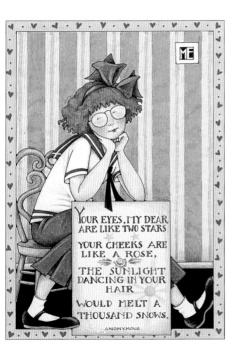

YOUR EYES, MY DEAR,
ARE LIKE TWO STARS

YOUR CHEEKS ARE
LIKE A ROSE,

THE SUNLIGHT
DANCING IN YOUR
HAIR

WOULD MELT A
THOUSAND SNOWS.

ANONYMOUS

Just for today...
flatter
someone.

■ ■ ■

Just for today...

Scatter seeds of kindness
 everywhere you go;
Scatter bits of courtesy—
 watch them grow and grow.
Gather buds of friendship,
 keep them till full-blown;
You will find more happiness
 than you have ever known.

—Amy R. Raabe

FRIENDS·BRING·A·CHEERFUL·HEART
AND·CONSCIENCE·CLEAR·ARE·THE·MOST
CHOICE·COMPANIONS·WE·HAVE·HERE

WILLIAM·MATHER

Just for today...
reach out
to others.

Just for today...
be hopeful.

HAVE·A·WONDERFUL·LIFE

september 19

IF THERE'S ANYTHING HALF SO MUCH FUN AS BEING ALIVE, I'D LIKE TO KNOW WHAT IT IS!

Just for today...
relish every
moment.

Just for today...
step lightly.

Take the gentle
path.

—George
Herbert

Just for today...
experience
the beauty
of autumn.

𝒟ays decrease,
 and autumn grows,
autumn in everything.

—*Robert Browning*

Just for today...
surround
yourself
with love.

A SMALL CIRCLE OF FRIENDS

■ ■ ■

One of the things
I keep learning is that
the secret of being happy
is doing things
for other people.

—Dick Gregory

Just for today...
let nature be
your teacher.

THE SIMPLE NEWS
THAT NATURE TOLD,
WITH TENDER MAJESTY.

EMILY DICKINSON

ME

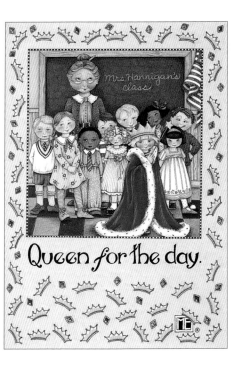

Mrs. Hannigan's class

Queen for the day.

Just for today...
stand in
the spotlight.

Just for today...
be warm
inside and out.

An open home,
 an open heart,
here grows
 a bountiful harvest.

—Judy Hand

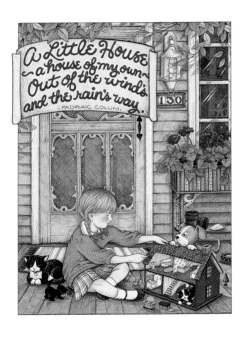

A Little House
~ a house of my own ~
Out of the wind's
and the rain's way.

· PADRAIC COLUM ·

130

Just for today...
keep it simple.

Just for today...
look on the
bright side.

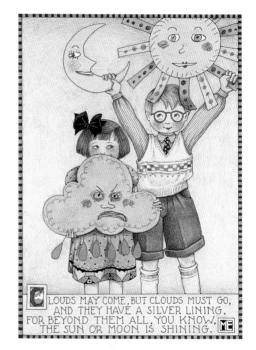

CLOUDS MAY COME, BUT CLOUDS MUST GO,
AND THEY HAVE A SILVER LINING,
FOR BEYOND THEM ALL, YOU KNOW,
THE SUN OR MOON IS SHINING. ME

september 29 ·

Just for today...
begin your
journey.

There is always one moment
in childhood when the door
opens and lets the future in.

— *Graham Greene*

Just for today...

To be kind to all,
 to like many and love few,
to be needed and wanted
 by those we love,
 is certainly the nearest
 we can come to happiness.

—Mary Roberts Rinehart

The New Associate

Just for today...
do what
it takes.

In teaching others
we teach ourselves.

—*Proverb*

Just for today...
educate.

Just for today...
play in
the leaves.

Music is love
in search of
a word.

—Sidney
Lanier

Just for today...
listen carefully.

Just for today...
do everything
with love.

\mathcal{N}o act of kindness,
 no matter how small,
 is ever wasted.
 —Aesop

You're never too old to have a happy childhood.

Just for today... enjoy life.

Just for today...

Fill the cup
of happiness for others,
and there will be enough
overflowing to fill
yours to the brim.

—Rose Pastor Stokes

Just for today...
take care of
the world.

HURT NOT
THE EARTH,
NEITHER THE
SEA, NOR
THE TREES

REVELATIONS 7:3

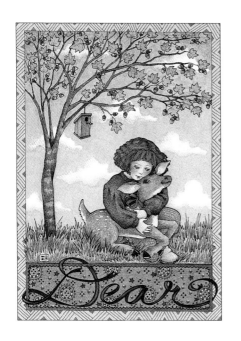

Just for today...
show a love
for animals.

THE

C · R · A · B

Just for today...
snap out of it.

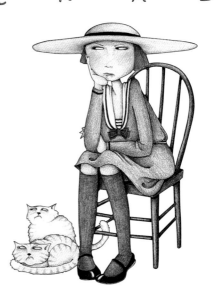

october 11 .

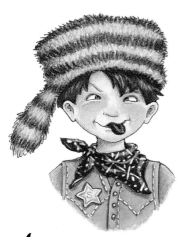

■ ■ ■

Just for today...
act silly.

It's fun being a kid.

—*Bradford Arthur Angier*

Just for today...
go for a walk
in the woods.

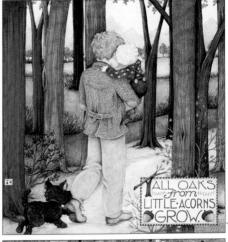

ALL OAKS
from
LITTLE·ACORNS
GROW.

october 13 .

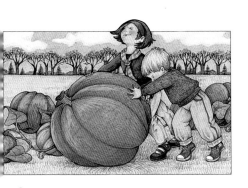

Just for today...
make a
decision.

It is truly said: It does not
take much strength
to do things,
but it requires great strength
to decide what to do.

—Chow Ching

Just for today...

Happiness is excitement
that has found a settling down place,
but there is always a little corner
that keeps flapping around.

—E. L. Konigsburg

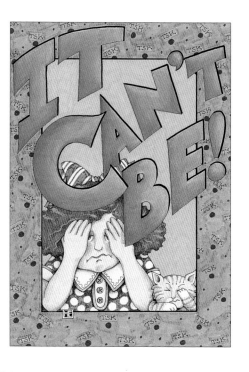

Just for today...
let it go.

Just for today...
keep shining.

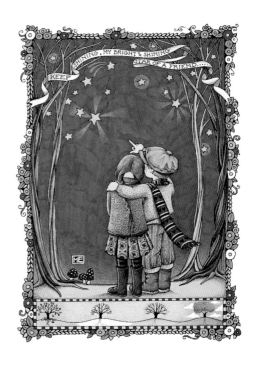

Just for today...
do more than
you have to.

A kind heart is
a fountain of gladness,
making everything in its
vicinity freshen into smiles.
—Washington Irving

october 18

Just for today...
be charming.

A Charmed Life

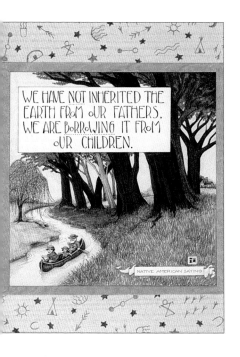

WE HAVE NOT INHERITED THE EARTH FROM OUR FATHERS, WE ARE BORROWING IT FROM OUR CHILDREN.

NATIVE AMERICAN SAYING

Just for today...
be gentle
with the earth.

Just for today...
contact
a friend.

\mathcal{I}n the sweetness of
friendship let there be
laughter, and sharing
of pleasures.

—\mathcal{K}ahlil \mathcal{G}ibran

■ ■ ■

Just for today...

*L*ook up,
laugh loud,
talk big,
keep the color in your cheek
and the fire in your eye,
adorn your person,
maintain your health,
your beauty and
your animal spirits.

—William Hazlitt

■ ■ ■

Just for today...
laugh it up.

*L*aughter can be
more satisfying
than honor;
more precious than money;
more heart-cleansing than prayer.

— Harriet Rochlin

october 23 .

Just for today...
make something
with your hands.

𝒯hou shalt sit on a cushion
 and sew a fine seam
and feed upon strawberries,
 sugar and cream.

■ ■ ■

Just for today...
open your
heart.

An open home, an open heart,
here grows a bountiful harvest.

—Judy Hand

october 25 .

TIME FLIES

WHETHER YOU'RE HAVING FUN OR NOT!

Just for today...
hang on.

For where your treasure is, there will your heart be also.

—Matthew 6:21

Just for today... treasure what means most.

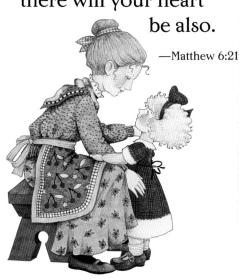

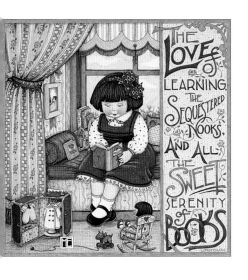

THE LOVE OF LEARNING, THE SEQUESTERED NOOKS, AND ALL THE SWEET SERENITY OF BOOKS

—LONGFELLOW

Just for today... lose yourself in a book.

Just for today...

The really happy person
is the one who can
enjoy the scenery,
even when they have
to take a detour.

—Sir James Jeans

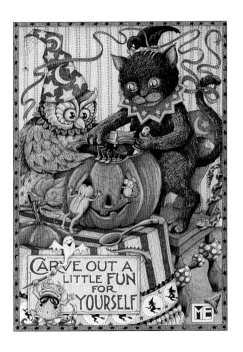

Just for today...
carve a
pumpkin.

CARVE OUT A
LITTLE FUN
FOR
YOURSELF

Just for today...
trick or treat.

october 31

\mathcal{D}evelop a passion
for learning.
If you do, you will
never cease to grow.

— Anthony J. D'Angelo

Just for today...
learn some-
thing new.

■ ■ ■

Just for today...
clown around.

LOVE

ONE ANOTHER

Just for today...
love one
another.

\mathcal{T}hou shalt love thy
neighbor as thyself.
—Romans 13:9

Just for today...
lead the way.

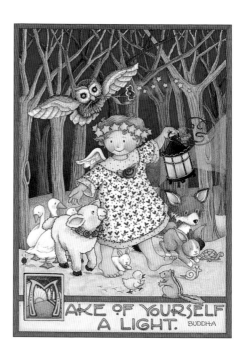

MAKE OF YOURSELF A LIGHT. BUDDHA

november 4 ·

■ ■ ■

Just for today...

Happiness is a tide:
it carries you only a little way at a time:
but you have covered a vast space
before you know that
you are moving at all.

—Mary Adams

Just for today...
show your
strength.

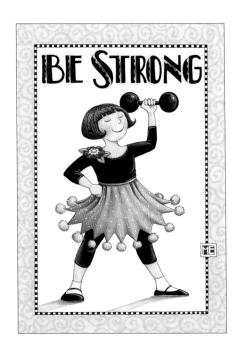

They shall grow
not old,
as we that are
left grow old:
Age shall not
weary them,
nor the years
condemn.
At the going down
of the sun and
in the morning
we will
remember them.

—*Laurence Binyon*

Just for today...
remember.

The family is the school of duties ... founded on love.
— *Felix Adler*

Just for today... spend time with family.

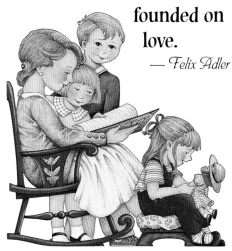

november 8 .

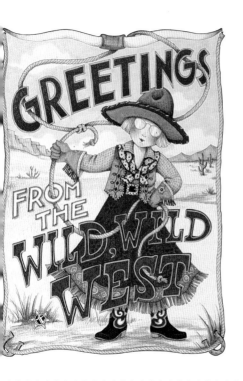

Just for today...
send a letter
to someone.

■ ■ ■

Just for today...
sleep in.

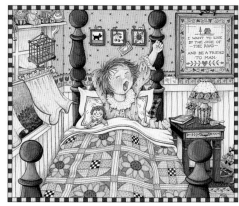

Oh, it's nice
to get up in the mornin',
but it's nicer
to lie in bed.

—Sir Harry Lauder

november 10

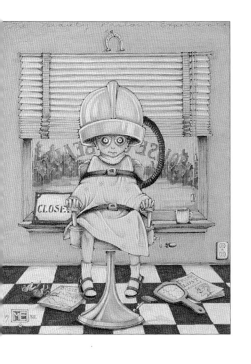

Just for today...
get your
hair done.

■ ■ ■

Just for today...

Remember that there is
no happiness in having or in getting,
but only in giving.
Reach out. Share.
Smile. Hug.
Happiness is a perfume
you cannot pour on others
without getting a few drops
on yourself.

—Og Mandino

november 12 .

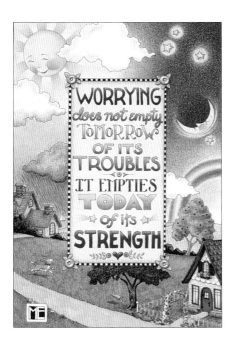

WORRYING *does not empty* TOMORROW OF ITS TROUBLES ◇ IT EMPTIES TODAY ✦ of its ✦ STRENGTH

Just for today...
don't worry.

Your vision will become clear only when you look into your heart... who looks outside, dreams. Who looks inside, awakens.

— Carl Jung

Just for today...
look inside
yourself.

*O*ther things may
change us,
but we start and end
with
family.
—*Anthony
Brandt*

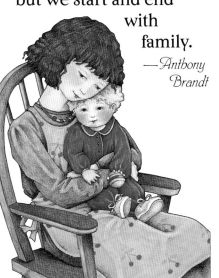

Just for today...
cherish your
family.

Just for today...
be a pal.

The difference between
the impossible
and the possible lies
in a person's determination.

—*Tommy
Lasorda*

Just for today...
be determined.

Just for today...
be yourself.

TO
THINE OWN
SELF
BE
TRUE

■ ■ ■

Just for today...

A ct happy,
feel happy,
be happy
without a reason in the world.
Then you can love,
and do what you will.

—Dan Millman

TWINKLE TOES

Just for today...
dance a little.

\mathcal{B}eauty
is the
promise of
happiness.

—*Henri B.*
Stendhal

Just for today...
be beautiful.

Just for today...
make a wish.

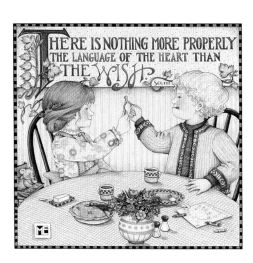

THERE IS NOTHING MORE PROPERLY THE LANGUAGE OF THE HEART THAN THE WISH. SOUTH

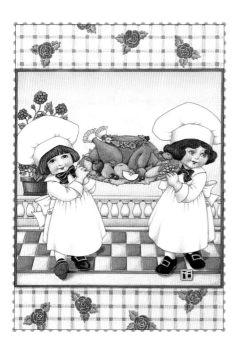

Just for today...
give thanks.

\mathcal{L}ove is the master key
which opens the gates
of happiness.

—*Oliver Wendell Holmes*

Just for today...
let happiness
flow.

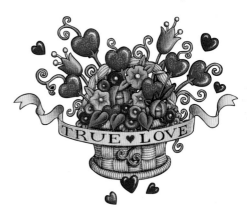

TRUE ♥ LOVE

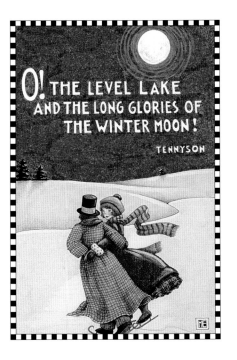

O! THE LEVEL LAKE
AND THE LONG GLORIES OF
THE WINTER MOON!

TENNYSON

Just for today...
let the moon
light the way.

■ ■ ■

\mathcal{T}he happiest people are those
who think the most interesting thoughts.
Those who decide to use leisure
as a means of mental development,
who love good music, good books,
good pictures, good company,
good conversation,
are the happiest people in the world.
And they are not only happy in themselves,
they are the cause of happiness in others.

—William Lyon Phelps

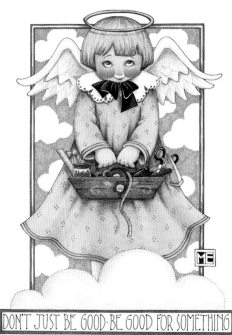

DON'T JUST BE GOOD·BE GOOD FOR SOMETHING

Just for today...
be good for
something.

\mathcal{N}o one can predict
to what heights you can soar,
even you will not know until you
spread your wings.

Just for today...
spread your
wings.

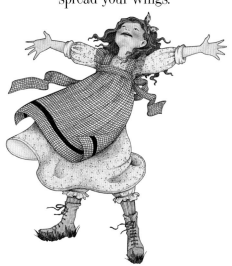

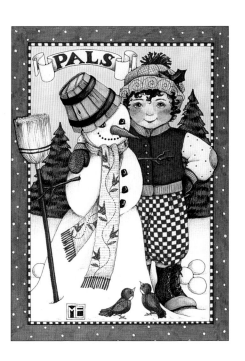

Just for today...
play outside.

■ ■ ■

Just for today...
be thankful.

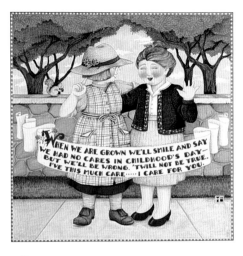

When we are grown we'll smile and say we had no cares in childhood's day— but we'll be wrong, 'twill not be true. I've this much care.....I care for you.

*Let us be grateful
to people who make us happy;
they are the charming gardeners
who make our souls blossom.*

—Marcel Proust

november 30 .

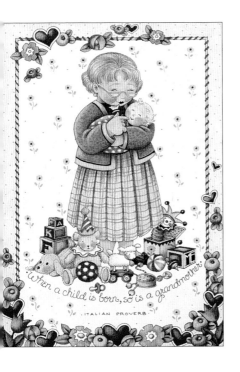

When a child is born, so is a grandmother.

·ITALIAN PROVERB·

Just for today...
smile at
a baby.

Just for today...
be calm.

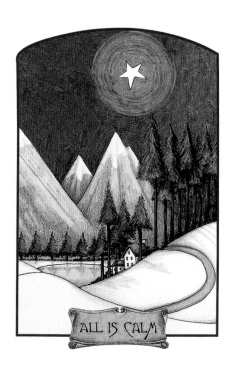

ALL IS CALM

december 2 ·

Just for today...

Happiness radiates
like the fragrance from a flower,
and draws all good things
toward you.

—Maharishi Mahesh Yogi

Just for today...
venture out.

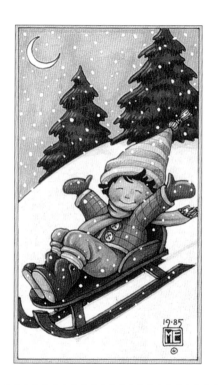

december 4 .

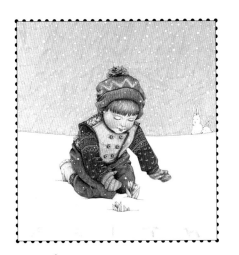

Just for today...
uncover the
beauty that
lies buried.

𝓗e was fresh and
full of faith that
"something would turn up."

—*Benjamin Disraeli, Earl of Beaconsfield*

Happiness consists not in having much, but in being content with little.

—Marguerite, Countess of Blessington

Just for today...
appreciate
what you have.

december 6 · · · · · · · · · · · ·

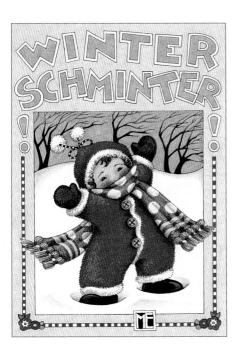

WINTER SCHMINTER

!!

Just for today...
play in the
snow.

Just for today...
have some
candy.

...a wilderness of sweets.
—John Milton

Just for today...
laugh
uncontrollably.

Just for today...

My creed is that:
Happiness is the only good.
The place to be happy is here.
The time to be happy is now.
The way to be happy is
to make others so.

—Robert G. Ingersoll

HAPPY HOLLER DAZE

Just for today...
get in the
holiday spirit.

Just for today...
breathe in
the night.

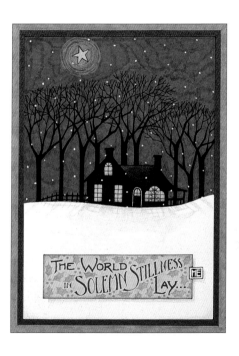

THE WORLD in SOLEMN STILLNESS Lay... ME

Just for today...
love a child.

\mathcal{A} baby is born
 with a need to be loved
and never outgrows it.

—\mathcal{F}rank \mathcal{A}. \mathcal{C}lark

Just for today...
look back.

REMEMBRANCE,
LIKE A CANDLE·····BURNS
BRIGHTEST
AT
CHRISTMAS TIME

Make yourself familiar
 with the angels and behold
them frequently in spirit;
 for without being seen,
they are present with you.
 — *St. Francis de Sales*

Just for today...
look for an
angel.

Just for today...
bundle up.

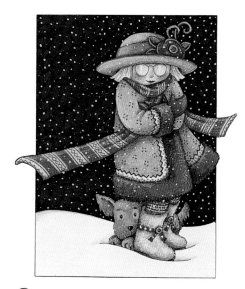

Every mile is two in winter.
—*George Herbert*

■ ■ ■

Just for today...

...the little hills rejoice on every side.
The pastures are clothed with flocks;
the valleys also are covered over with corn;
they shout for joy, they also sing.

—Psalms 65: 12 and 13

Just for today...
let a friend
guide you.

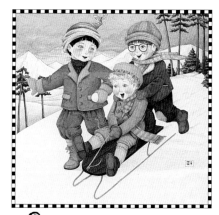

Each friend represents
a world in us, a world possibly
not born until they arrive,
and it is only by this meeting
that a new world is born.

—Anaïs Nin

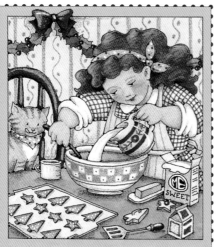

IT IS A FINE SEASONING
FOR JOY ❧ TO THINK
OF THOSE WE LOVE.
·MOLIERE·

Just for today...
bake some
cookies.

Just for today...
be gentle
and kind.

*Power is the
ability to do good things
for others.*

—*Brooke Astor*

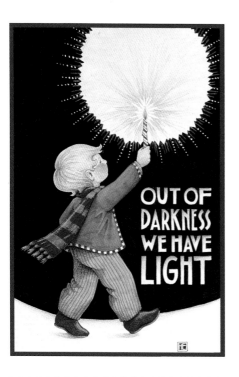

OUT OF
DARKNESS
WE HAVE
LIGHT

■ ■ ■

Just for today...
light the way.

Just for today...
light a candle.

We shall
light a candle
of understanding
in our hearts
which shall not be put out.

May your
Christmas
be a Happy One
And may the
New Year bring
you
Contentment
and Prosperity
in overflowing
measure.

Just for today...
let excitement
build.

Just for today...

Happiness is essentially
a state of going somewhere,
wholeheartedly, one-directionally,
without regret or reservation.

—William H. Sheldon

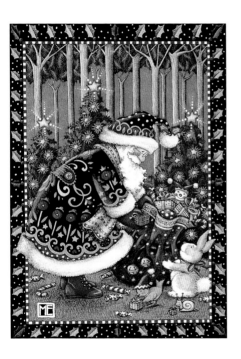

Just for today...
be merry.

Just for today...
think warm
thoughts.

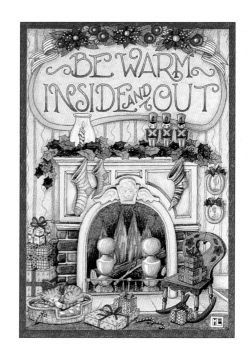

BE WARM
INSIDE AND OUT

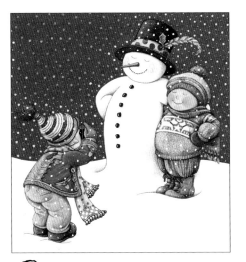

Just for today...
make a new
friend.

\mathcal{G}ood friends are good
for your health.

—*Irwin Sarason*

Just for today...
let love
take flight.

Love, free as air
at sight of human ties,
spreads his light wings,
and in a moment flies.

—*Alexander Pope*

december 28 .

HAVE FAITH

Just for today...
remember
spring.

Just for today...

Make happy those
who are near,
and those who are far
will come.
—Chinese proverb

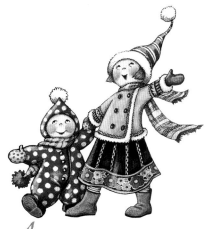

Just for today...
ring in the
new year.

In the New Year,
may your right hand
always be stretched out
in friendship,
but never in want.

—Irish toast

Just for Today,
Be Happy